the artist would like to thank...
my Mother and Father, Mark, John and their families, Sinwin,
Cray Ray, Whits, Kyle and Alison, Lowbeam, IBH, A.Pommier,
John Esguerra, AssEgg, Man Hat Man, Go Jo, Holmes, Muma,
Danny Boy, Steve and Kristin, Mikey, Faile,Yohko, Yone and
The Thunderbirds, Delphic, Kozyndan, Apples, The Local
Artists crew, Soft Citizen, Tony and the Alife crew, Arkitip,
Mark and Sara, Peter Thaler, Kettleby.

Published by Magic Pony
694 Queen St West
Toronto ON Canada
Visit our website at www.magic-pony.com

Copyright 2005 Magic Pony
All artwork copyright 2005 Derrick Hodgson
All rights reserved
Printed and bound in Canada
First Edition

Design: Steve Cober / Magic Pony

The Art of Derrick Hodgson

Gaping Maws & Vacant Eyes

Picture an old lady eating a strawberry ice cream cone. Beside her stands a young male, plainly dressed. His name is Jim Stickney. They are not related and have no apparent reason to be standing next to each other. Both are slightly dwarfish and have gaping mouths, but neither one is quite remarkable. They express neither joy nor sadness – they are just standing there. Not much of a picture, I know. Quite dull actually. I did, however, forget to mention Jim's escorts – two reclining beefers with cavernous mouths, completely naked, save for their pink tit slings. There are also three zombie farmers – Randy, Ronnie, and Reggie – standing hunched over and off to the side. They seem a bit threatening for knuckle draggers, but it's hard to tell whom they're after. Maybe it's Jim Stickney. Or the ice cream. Quite possibly it's the stumpy grey mogos slothfully lurking in the foreground. A space ape stoops and stares in the background, unfazed by the mania building all around. Beside him slouches a zombie scout – perhaps the offspring of Randy, Ronnie, or Reggie – who should appear concerned by the fifty or so floating heads and phantom shapes zooming and zipping above his head, but naturally he isn't. No one, in fact, is much aware of anything, which might seem rather odd to you or me, especially considering the ongoing disorder. But to my brother, Derrick Hodgson, this picture captures any random day here on earth. It presents something real. Madly real and really mad.

As his younger brother, I've been looking at Derrick's creations for a very long time.

From his childhood doodles of cows and commandos to his teenage dabbles in the psychedelic to his latest offerings here in this book, I've watched Derrick grow as an artist. And what I've come to realize – and respect – about him is his willingness to bare all the strange fruits of his imagination. There is something both fearless and fearful about Derrick's work. Fearless because he is unafraid to let disorder descend onto the canvas. Fearful because Derrick draws this disorder from the world he sees – the world we live in. You might not see this when you first look at one of his paintings. You might scratch your head in puzzlement. You might smile or laugh. But if you stare at the painting long enough, and let your mouth open just a little, you'll begin to see something familiar in the images. Not a self-reflection per se, but a mirroring of the mad reality all around us. Lord knows I see my fill of Jim Stickneys and space apes every day I walk down the street. And there is certainly nothing strange about that. Now, if you'll excuse me, I have a few zombie farmers to contend with.

John Hodgson
Spring 2005
Chelsea, Quebec

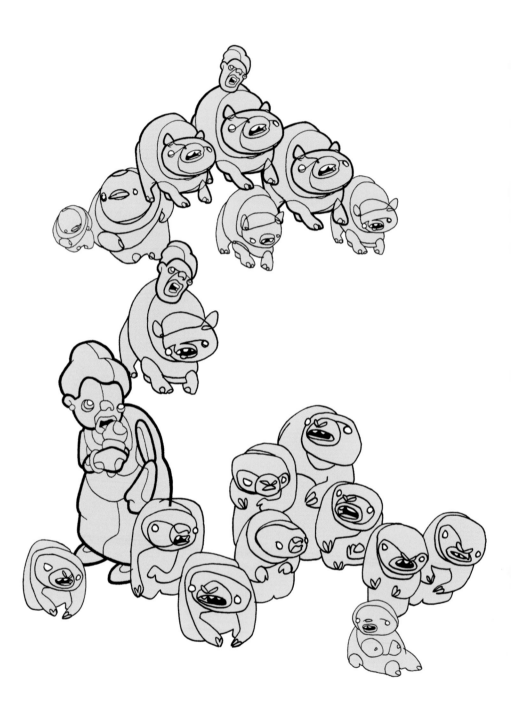

Character
Farming

1999 - 2005

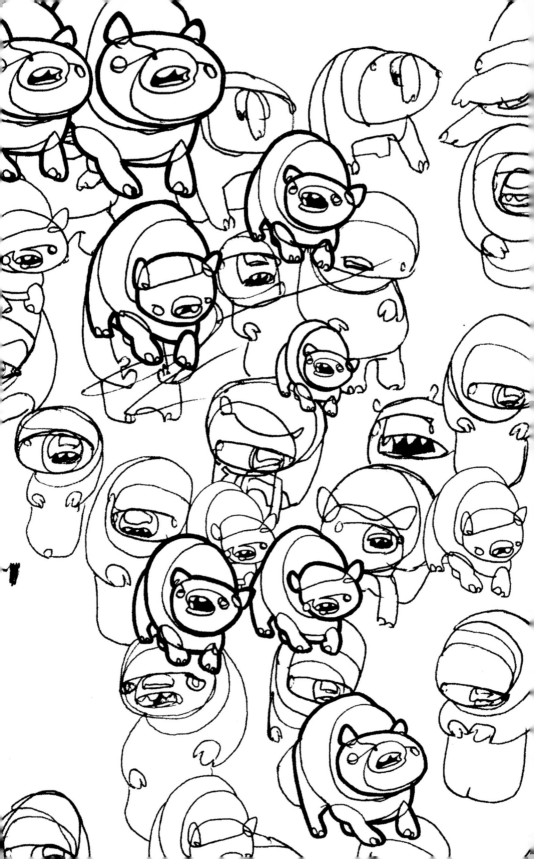

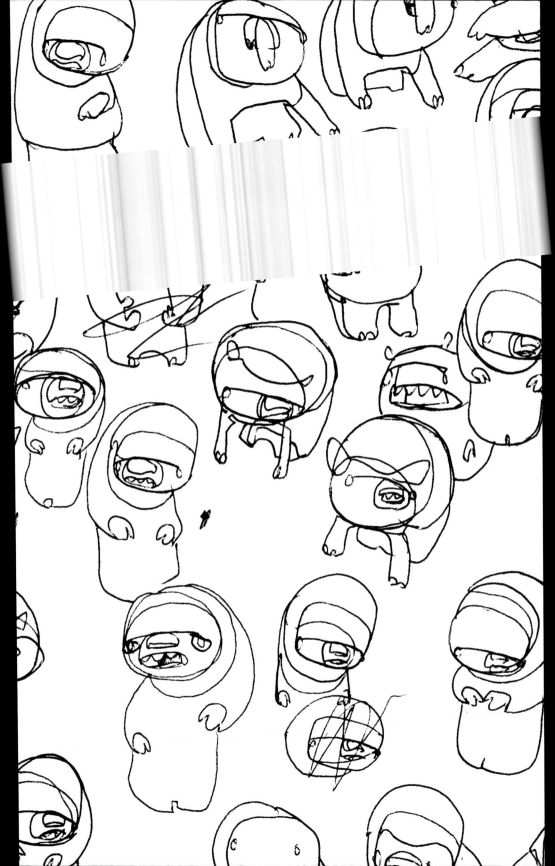

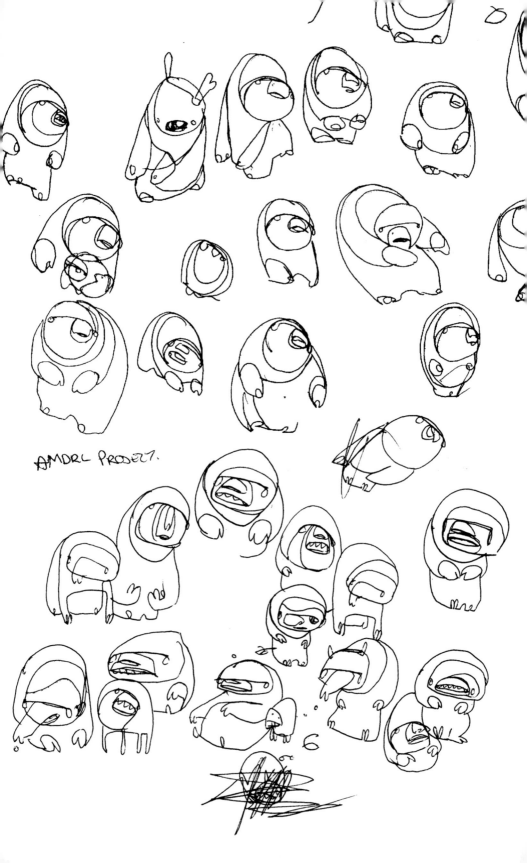

AMDRL PRODELI.

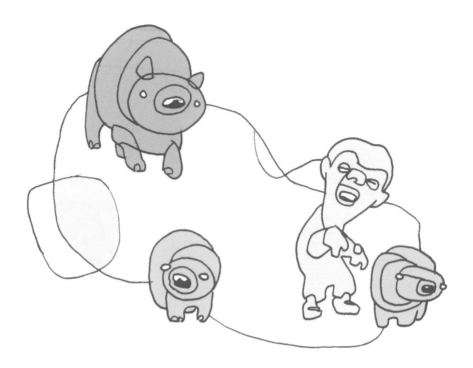

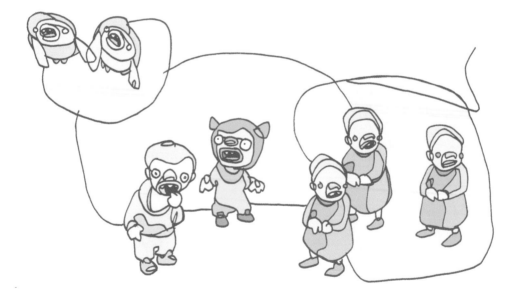

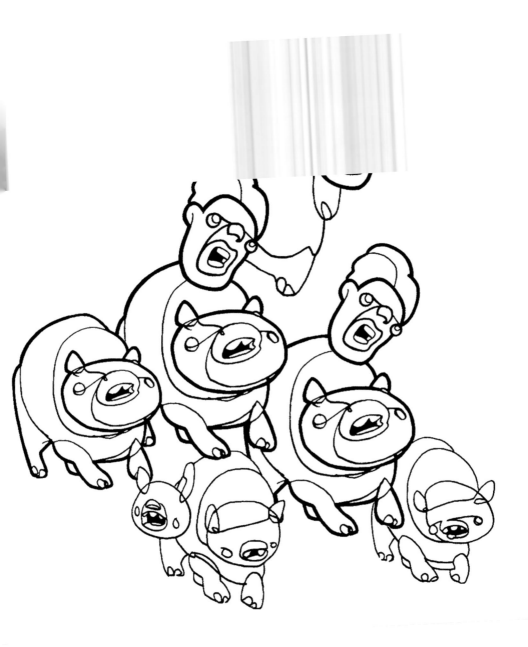

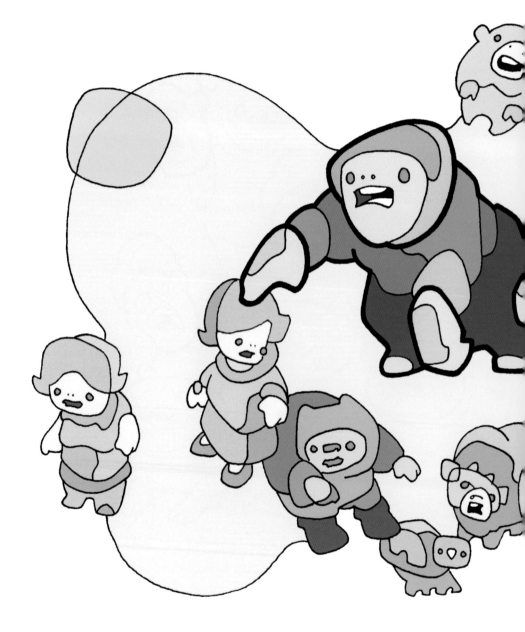

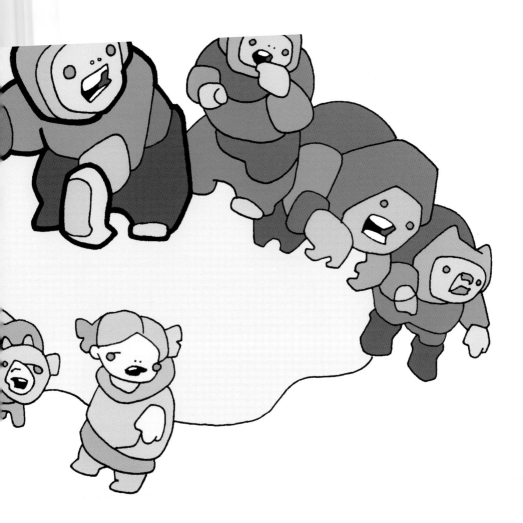

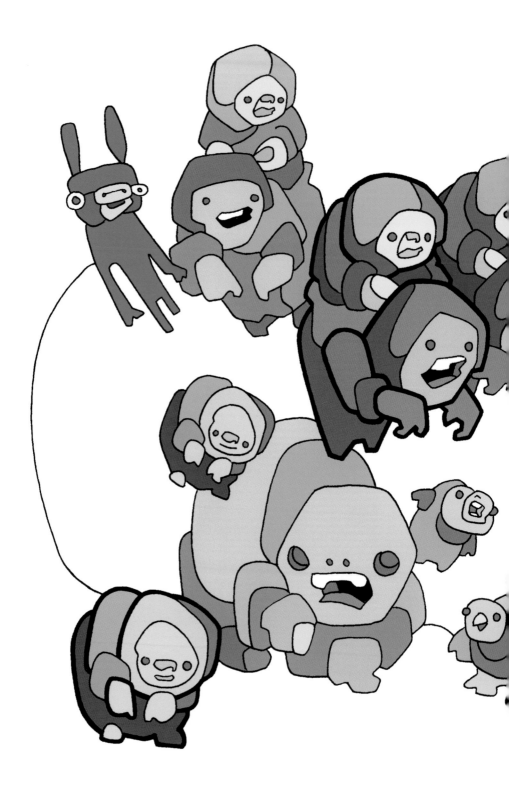

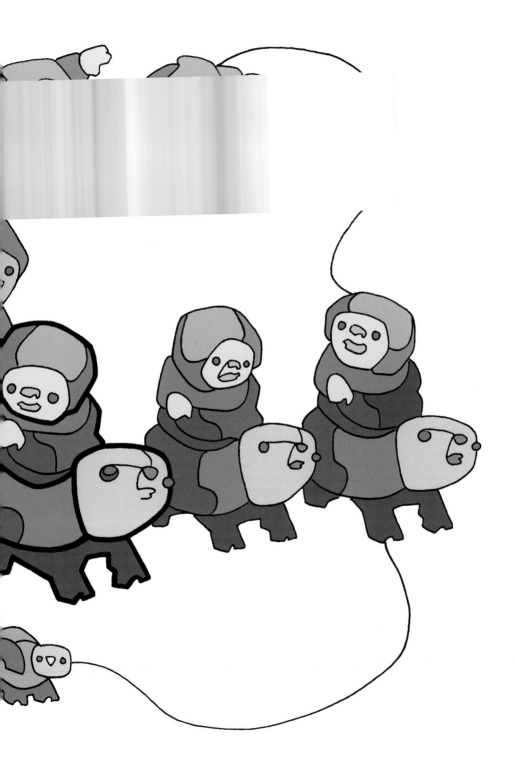

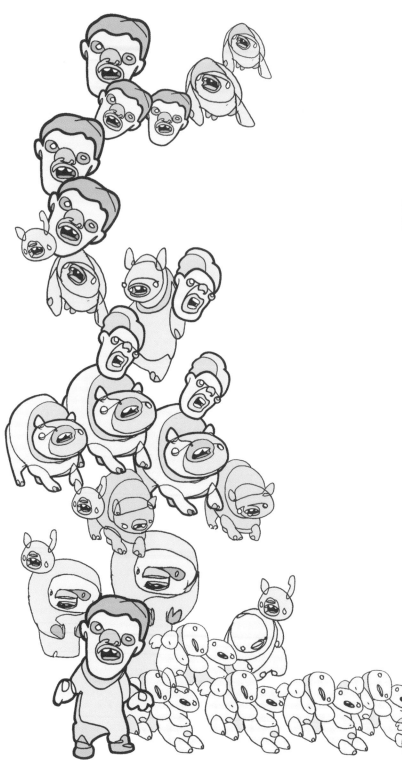

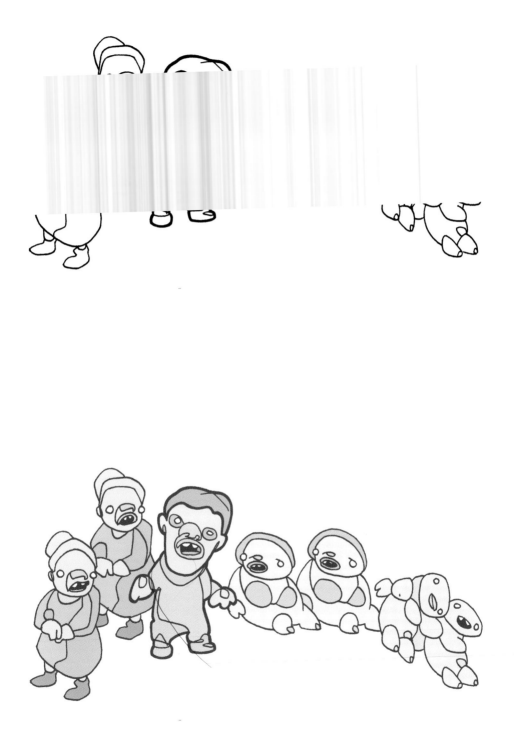

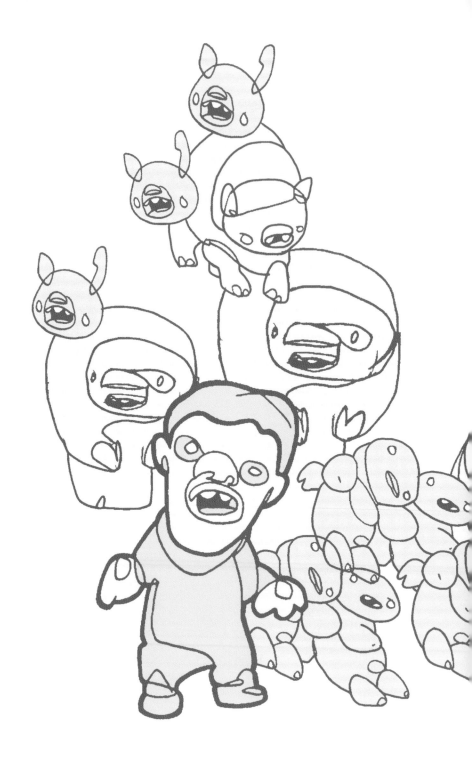

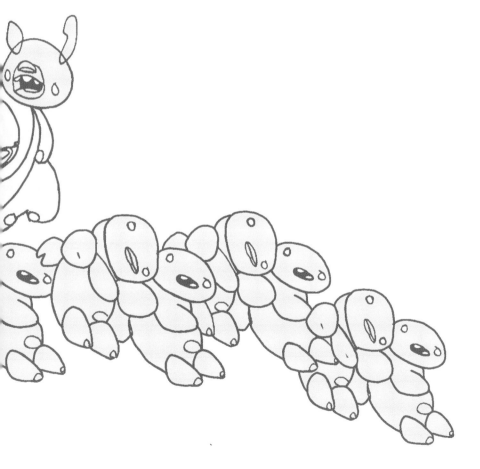

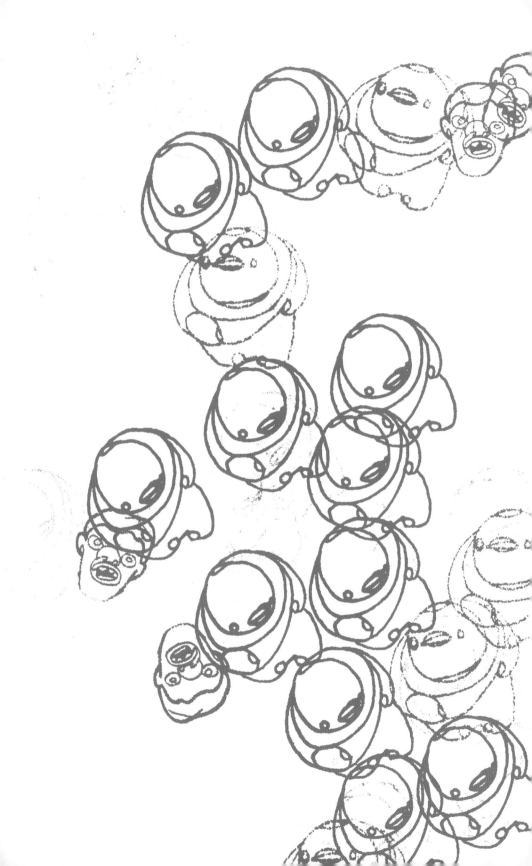

Mash Ups

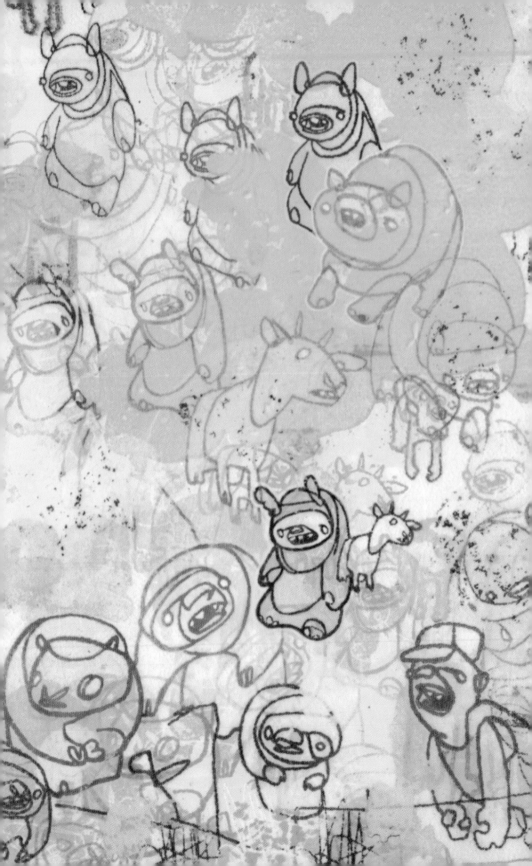

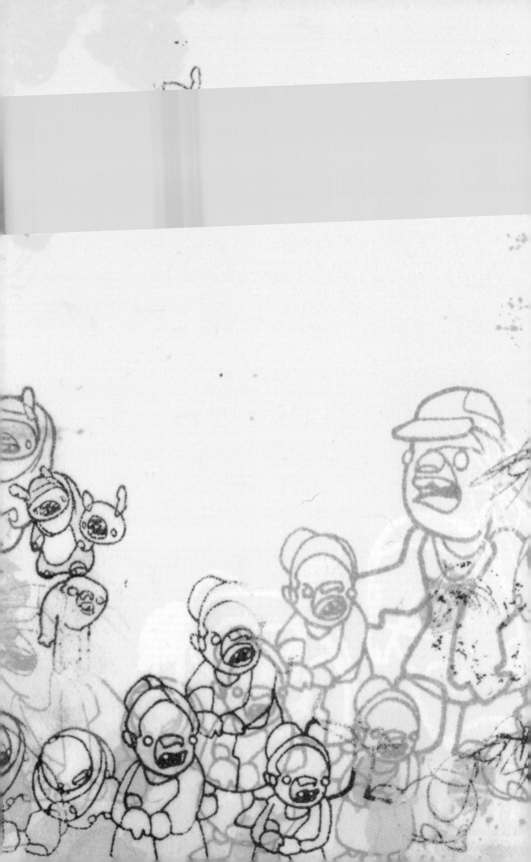

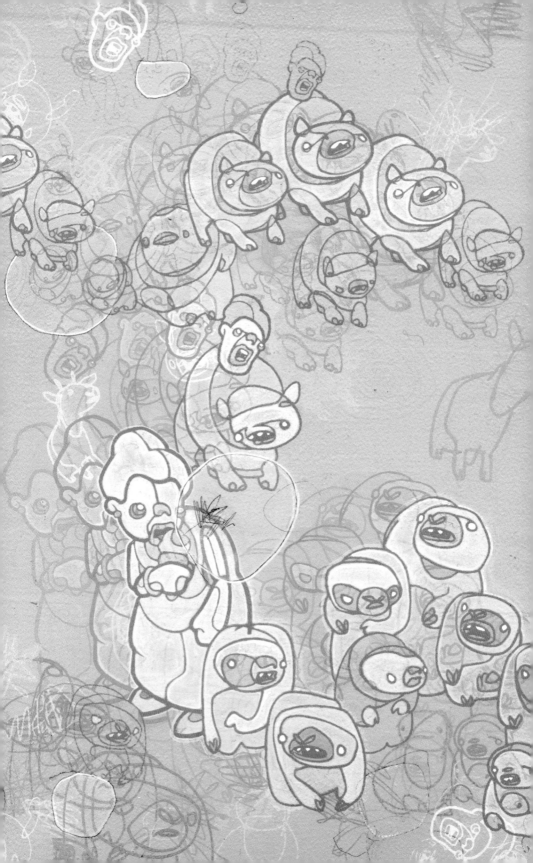

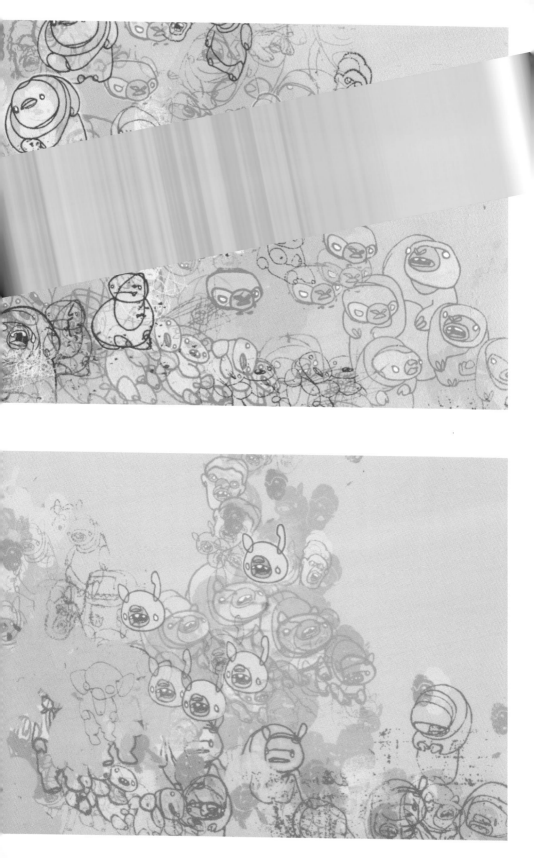

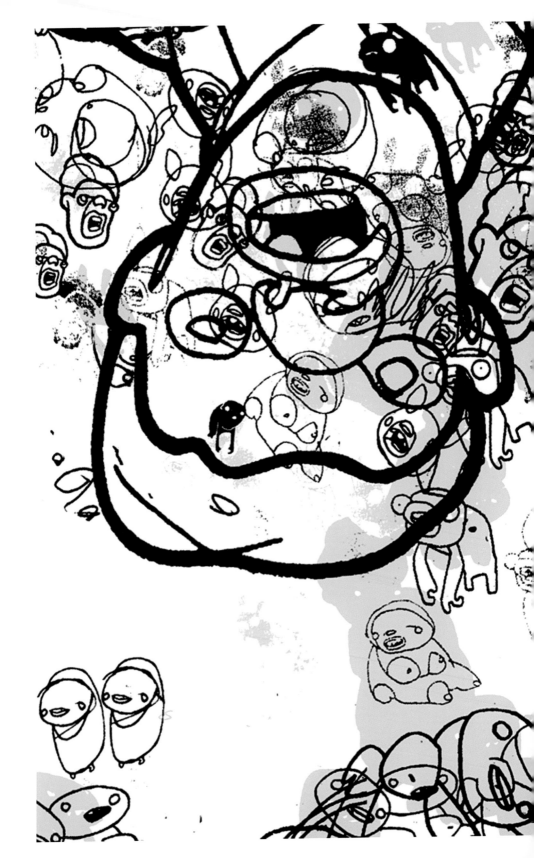

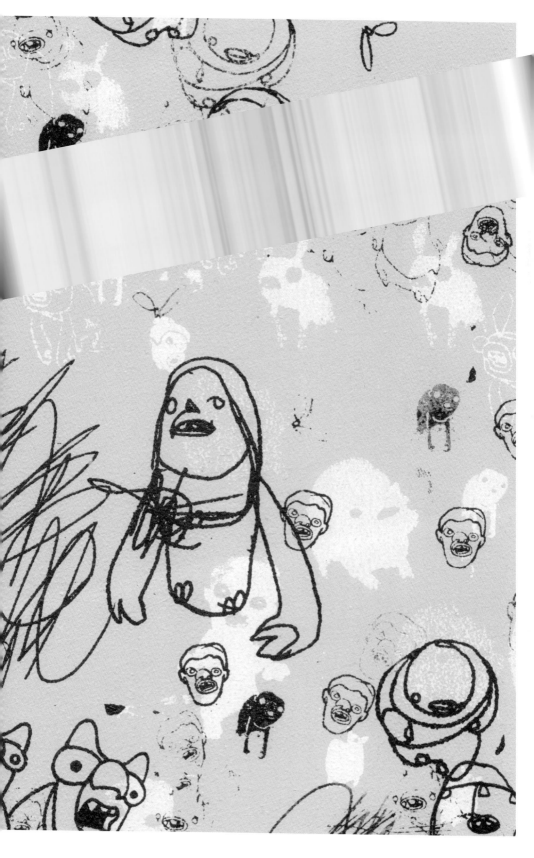

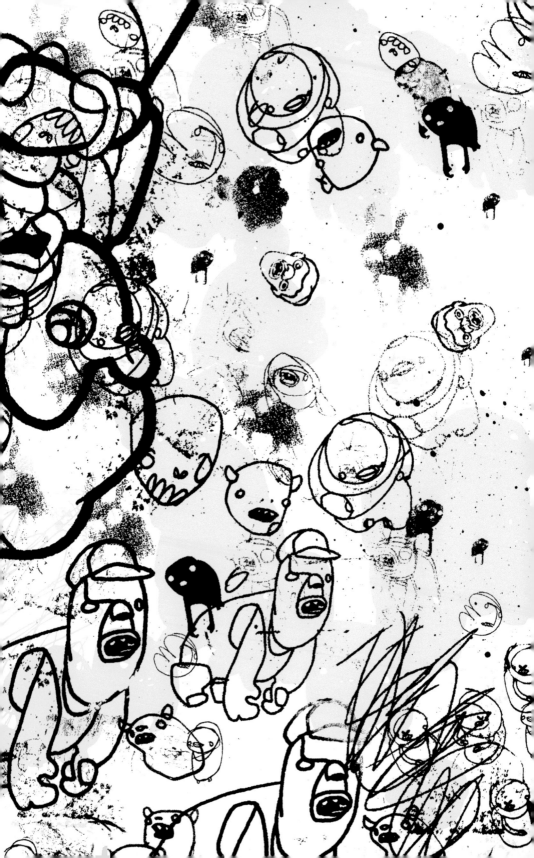

Interview with Derrick H~~

From All Maple Magazine ~
Interview b~ ~

... a small rural
, .v. ... north of Toronto and relating
these experiences to the expanding urban
environment I find myself in at present. My
recent work has been dealing with a theme
of rural meets urban and the urge to gain
control over our future in relation to an esca-
lating loss of nature.

My paintings and drawings are renderings of
complex social spaces crowded with famil-
iar and mutated characters. I use repetition
of character to illustrate ideas of technologi-
cal advancement and the consequences of
such advancement.

Aesthetically I combine aspects of cartoon,
graffiti and contemporary design to produce
my own illustrative style. My "style" is a fu-
sion of imagery absorbed while growing up
on the family farm and living in my present
urban setting. I rely heavily on my imagina-
tion, but base themes for my work on reality
and my immediate surroundings.

Repetition is a very strong element in your
work. You seem to run that knife-edge of
just enough random chaos and obliterating
your own message. Did it take you a while
to get a feel for when you were going over-
board with repetition? Or is it something
you are always pushing the limit of?

well, sometimes I think I do go overboard
with the repetition but that's all apart of my
process... the composition can start out
very simple and then by placing random
packs of peepers on top of packs of floaters

... surrounded by
... it all kinda turns into one big
stew of line and colour...somewhere in the
stew I find a balance and when I find the
balance I usually step away from the work...
sometimes I go back and hit it up again ...
there is a digestion process... Repetition
for me in my work comes from my farm-
ing background and rural upbringing...
seeing rows upon rows of corn or wheat or
whatever... season after season... I look at
each of my characters as a kinda 'seed' ...
when I find a character in my doodles that
seems just 'right' I place it in my 'seed bank'
... I pick certain 'seeds' out of the 'bank' and
combine them with other 'seeds' to produce
a 'crop'... year after year I add to my 'seed
bank' always mixing and matching, produc-
ing new crops... it's all about farming the
'idea' and growing...

When I look at your work I always think of
the armies of bloated mindless zombie's
from Dawn of the Dead. I had heard
someone say that the Dead movies were
Romero's comment on technology and a
warning to the future. At the time I thought
that it was over-intellectualizing a zombie
flick but you have said here things that are
reminiscent of that idea. Would you care to
expand on that idea a bit?

without being too rhetorical, there is under-
lying political meaning in my work... I really
don't want to expand on this... it could get
boring...

What was your first job right out of art school?

after art school I moved out west...Toronto was driving me crazy...I spent every summer planting trees in the Monashee , Kootenay and Selkirk mountains... the work paided for my tuition...I had friends scattered around the valleys of southeastern British Columbia so I decided to switch it up and spent a full year living in the mountains... technically my first job out of art school was planting trees... my first art related job was doing illustrations for an 'alternative' newspaper called the 'Barter Bulletin' It was a 'green' publication that promoted environmental awarness... good stuff... I was payed in 'barter bucks' a type of alternative economic system based around the idea of trade... long story... mellow times...

How did it lead to where you are today?

Kootenay 'barter bucks' can only get a fellow so far... I moved to Vancouver to be with my older brother and his new family... I did a little recon of the west coast scene... hooked up with a good friend Kyle McIntosh a fellow tree-planter turned web designer... Kyle helped get madreal.com up and running... for the record, madreal is not my 'handle' or aka... it was only ever supposed to be the title for the space I hold in the world wide web...it is so funny when people refer to me as "madreal" like it is my name... Derrick is my name, madreal is my space in the web, mdrl is my studio title... anyway I moved back to Toronto and established mdrl creative in 1999...I have worked outta of my little urban camp here in Parkdale, Toronto ever since...

How early in your career were you able to break from client work to exclusively work on Madreal exclusive and themed client projects?

I never really 'broke' from client work in the beginning cuz I didn't have any clients...I am more concentrated on building a recogniz-able 'style' that lends itself to many differ-ent types of projects ... I have been very fortunate thus far that the majority of my client work has been a type of co-branding between myself and the client and I have had full creative control and freedom with these projects... it's always themed.

There's a certain reality of client work that every professional artist has to face. Many of your client pieces seem to be more Madreal/Hodgson originals than brand centered. How have you managed to retain so much control creatively with your com-missioned pieces?

that is a good question and I really don't know how to answer it... again all the client work that I have done has been this sort of co-branding between my world and the clients project... I think it all comes back to this idea of repetition in my work...

Is there a project that has stood out for you in your client work?

The Sony Art capsule Toy project was a good one... It was amazing having the "creatures of mass mania" be produced and infiltrate homes around the world...I really enjoyed working with the Japanese design team at Sony Creative Products... the 4am conference calls were always a mind bender... I can't speak Japanese and I'm sure they had problems with my Canadian hick slang...very interesting.

...y talented craftsman... check www.logicsnowboards.com on the show front, Andrew Pommier and myself will be in LA in the Spring for a show at the lab101gallery in Culver City... give www. thelab101.com a peep...

...ᴑᴇ project then I ...ᴇ... we have plans to expand a little...

Tell me about the Hoboyard and how you got into designing figures?

The "Hoboyard Toy Co." is a project that was started with my partner, Toronto artist Tania Sanhueza... way back when, Tania crafted a mega stuffed creature for me as a gift... The Bluebee she crafted was amazing... we decided that it would be fun to birth a batch of Bluebees... we sat down, produced a prototype and proceeded with the first batch of stuffed critters under the collective name "Hoboyard Toy Co." we call the vacant lot between my building and the traintracks the "hoboyard" so that's where the name comes from... in the past years Tania and I have alternated between her designs and mine and we have produced a number of characters Bluebee, Cicio, Chammy and Tania's latest "Stovepipe"... Tania does the majority of the work cuz I have no sewing skills... I take care of marketing, screen-printing the packaging and being a stuffer.

Has it been a successful venture or has it been more about the fun of it?

Toys are fun... the 'hoboyard' project was started more as an art project then a com-

there is only so much we can do with Tania's pink sewing machine... but it has been a successful venture ...Bluebee's , Cicio's and Chammy's have all found homes around the globe...

Do you collect figures and other toys? If so what have you picked up recently?

I have a toy collection but the majority of them have been given to me by aother creative folk that produce toys and stuff... I'm a big fan of the Devil Robots from Japan I think their TOFU head character is very amusing...when I was in Singapore for the IDN conference last year I chilled with the crew... they asked me to draw on a blank tofu figure and they drew on one ... what came out in the end can be seen on my website if you scroll through the pics...I think James Jarvis is geezer... I love what he and Russell Waterman are doing with AMOS toys.

Thanks for taking the time to talk to us. Do you have any final words?

Thanks Dave and Maple ...

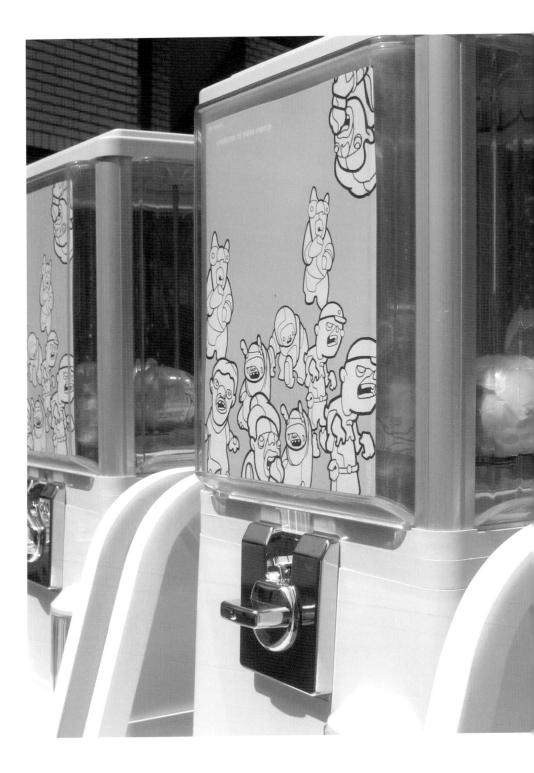

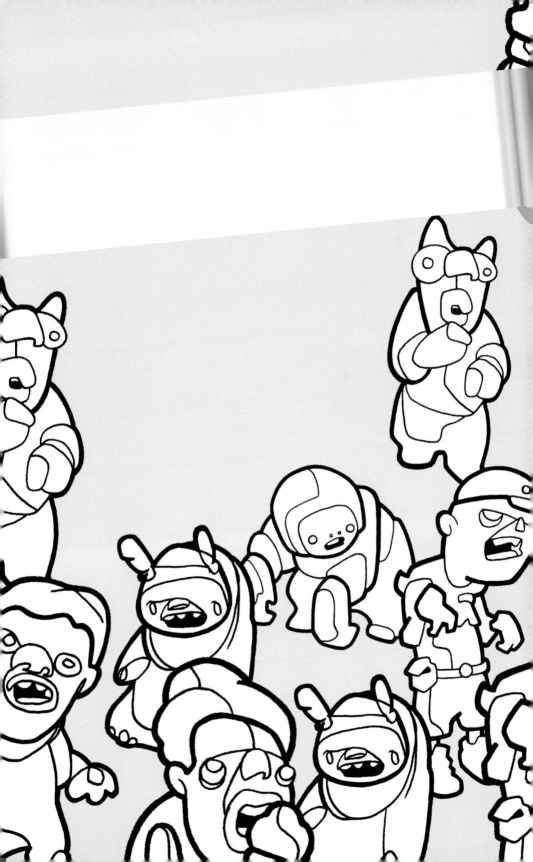

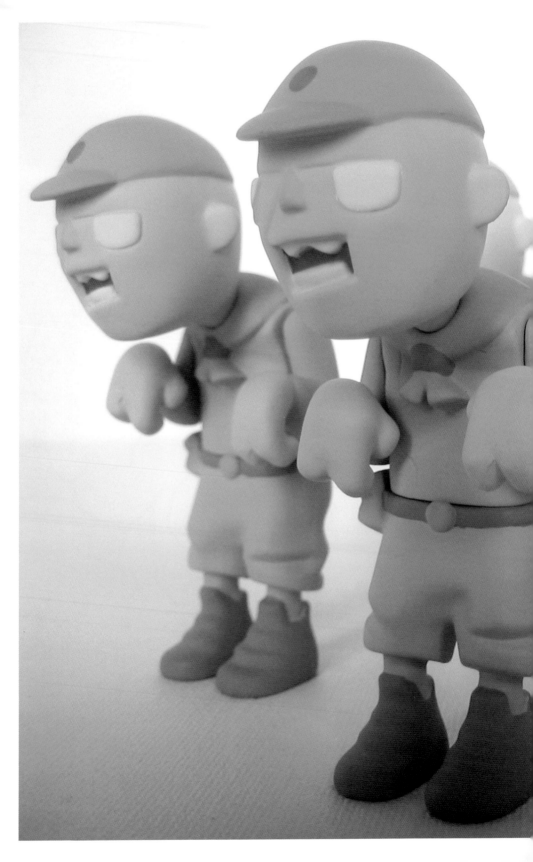

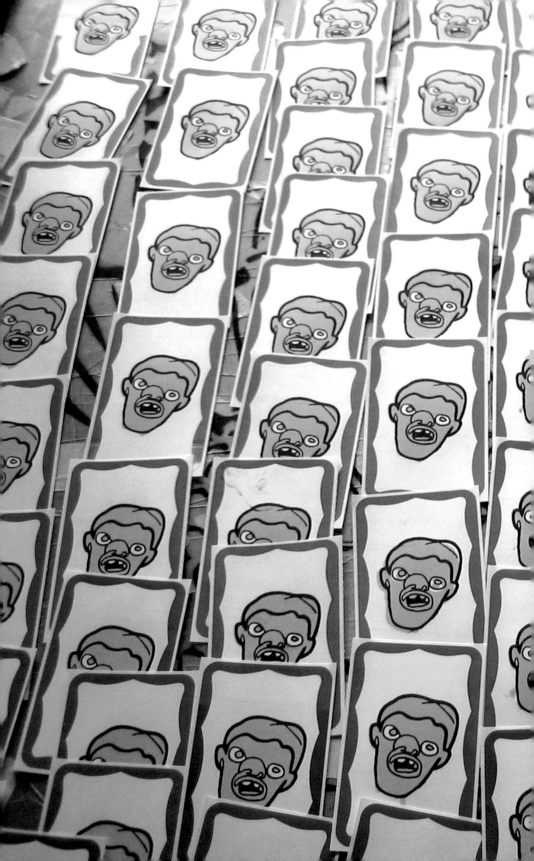

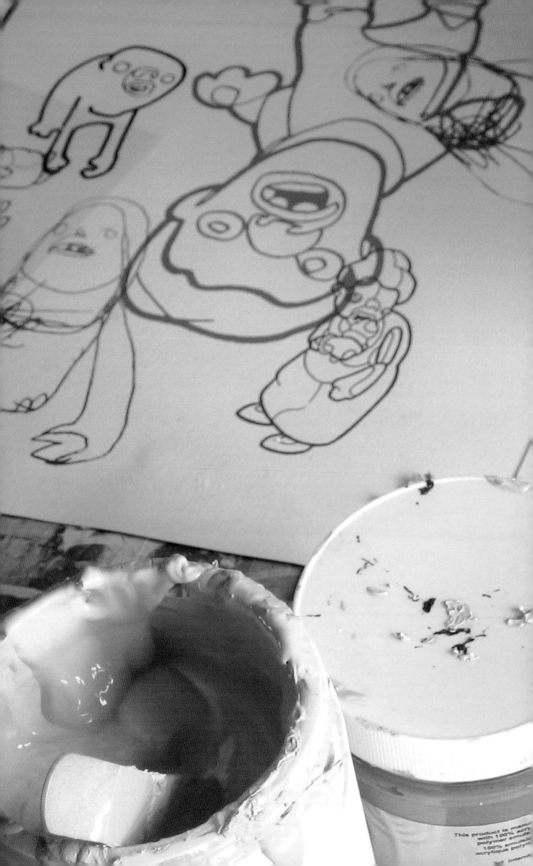

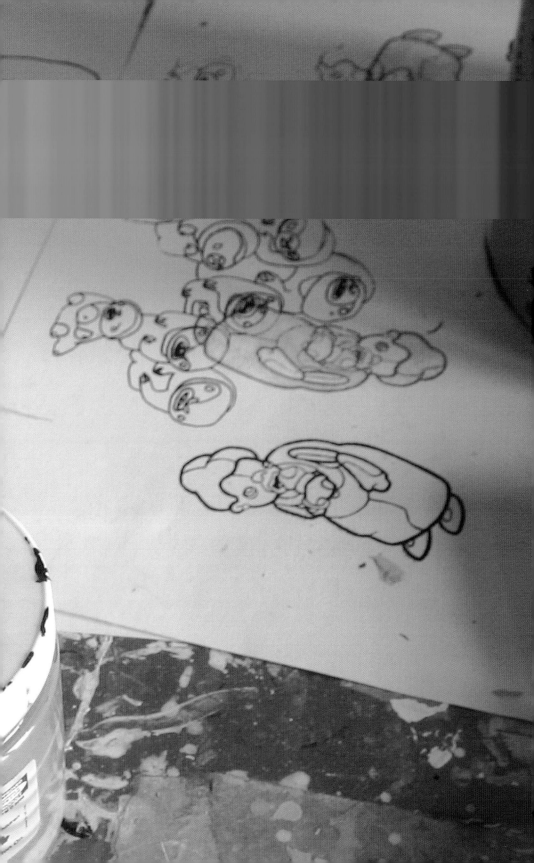

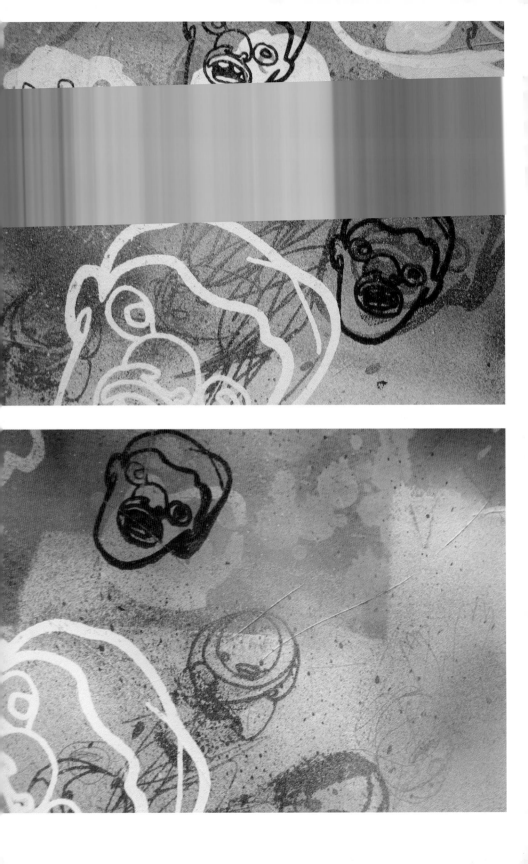

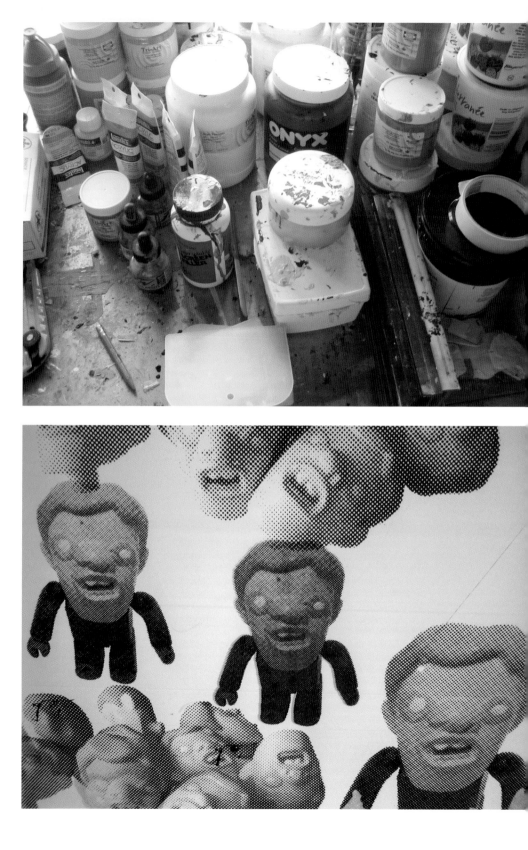

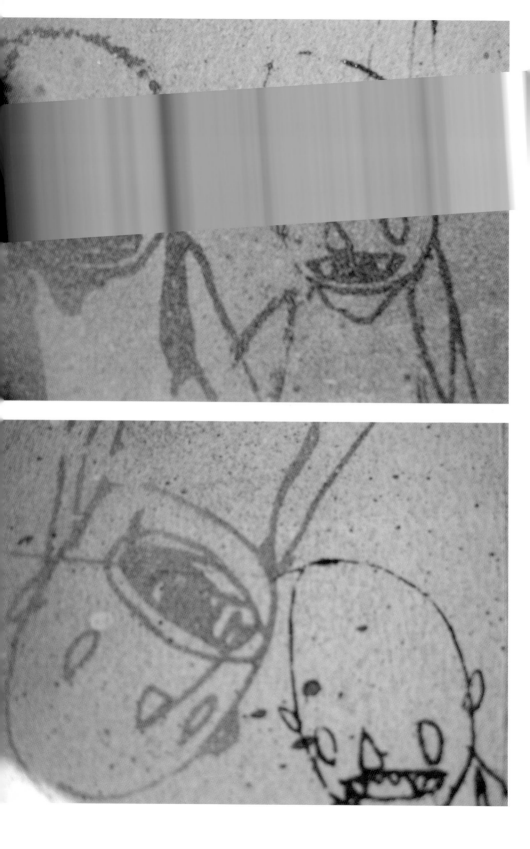

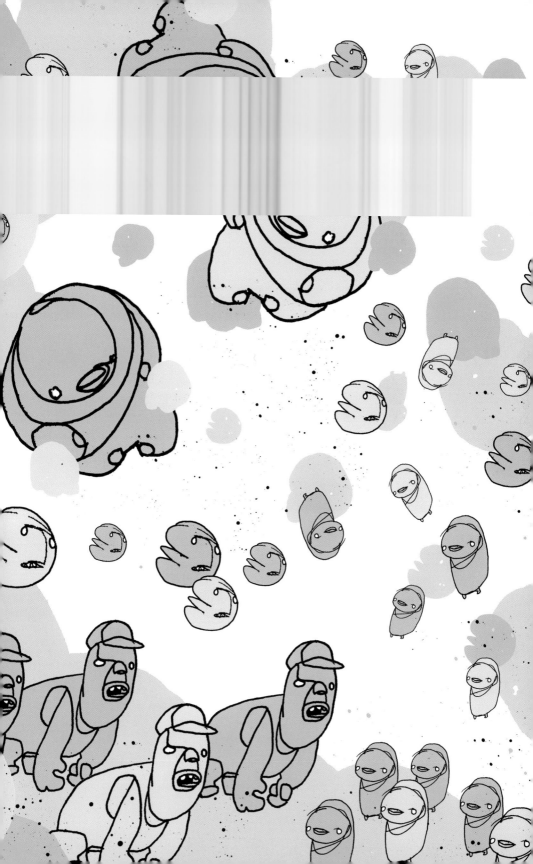

peepers
poppers
floaters
walkers
sprouts
spores
ghouls
mogos

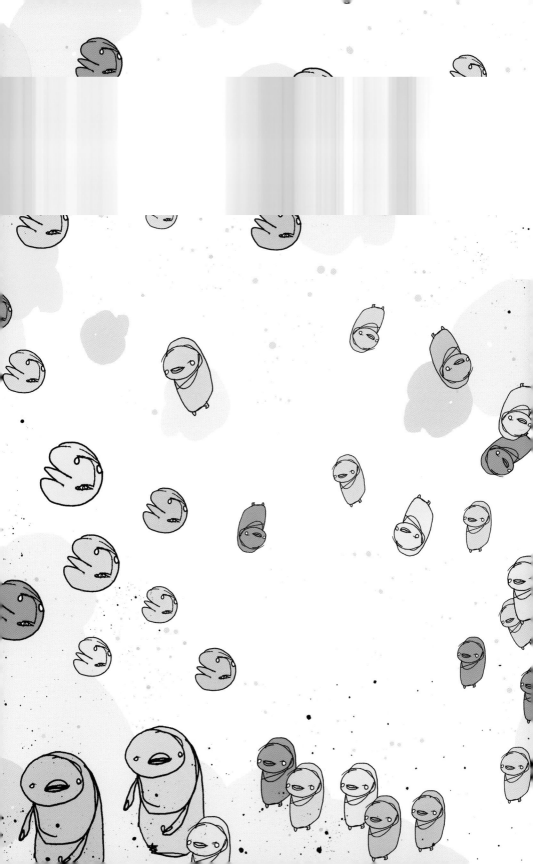

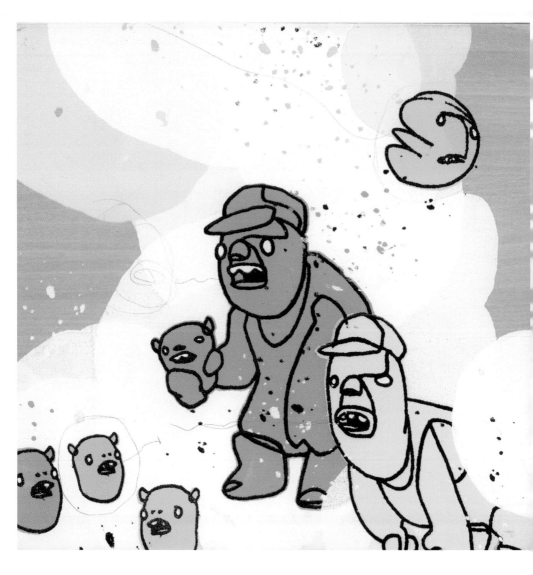
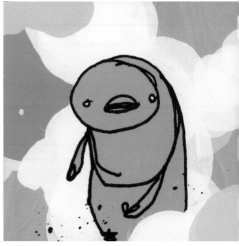

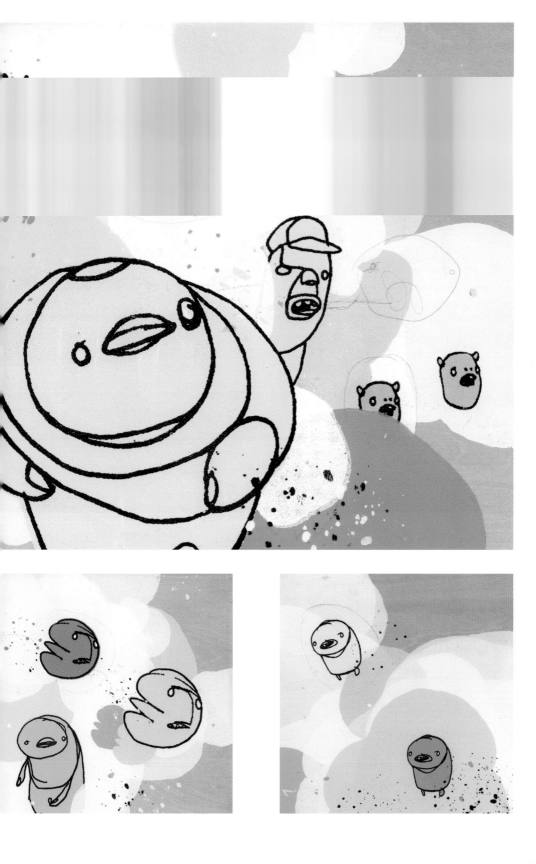

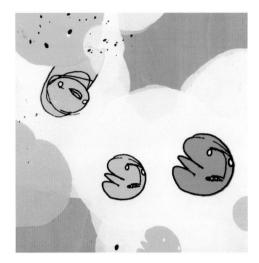

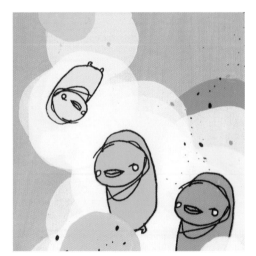

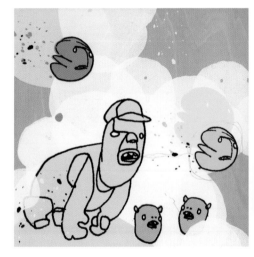

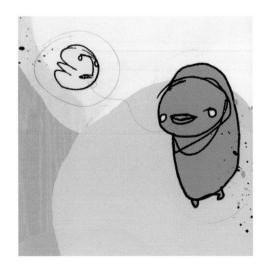

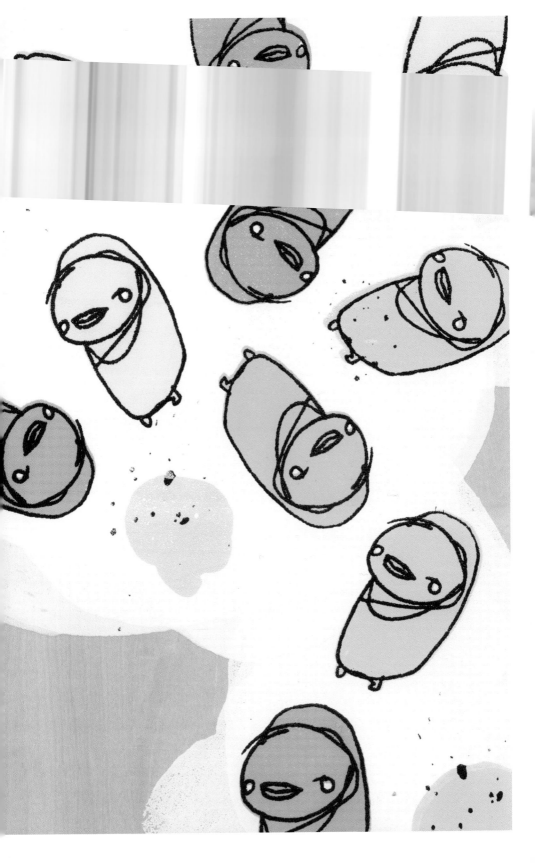

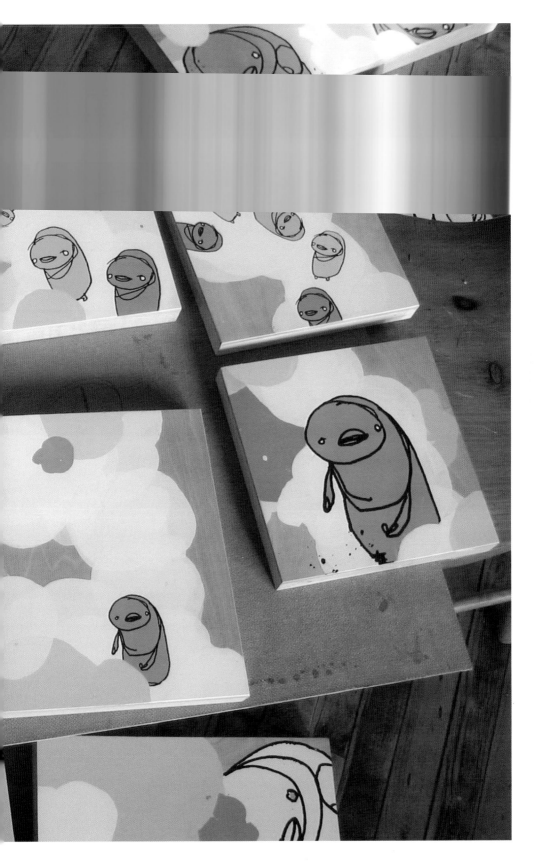

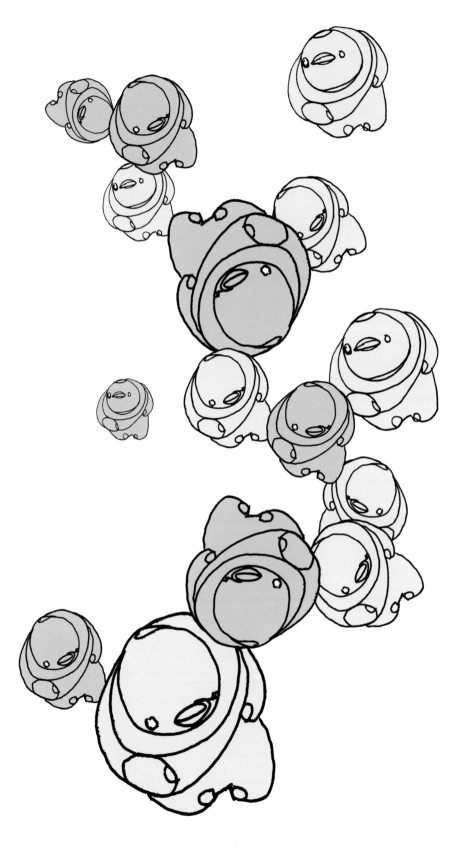

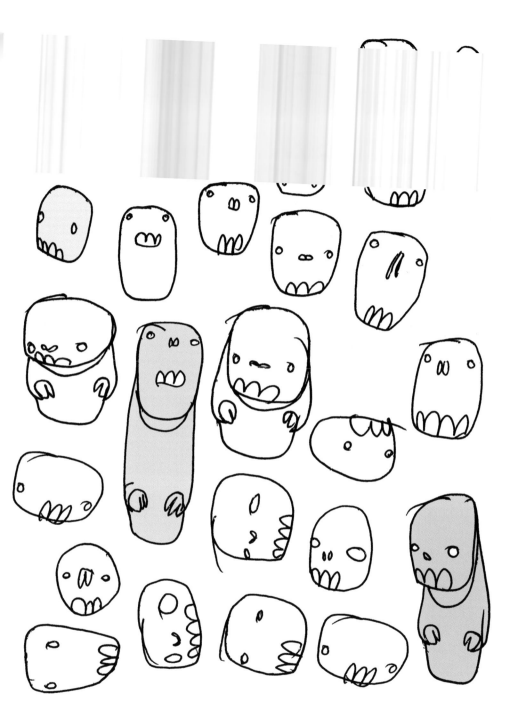

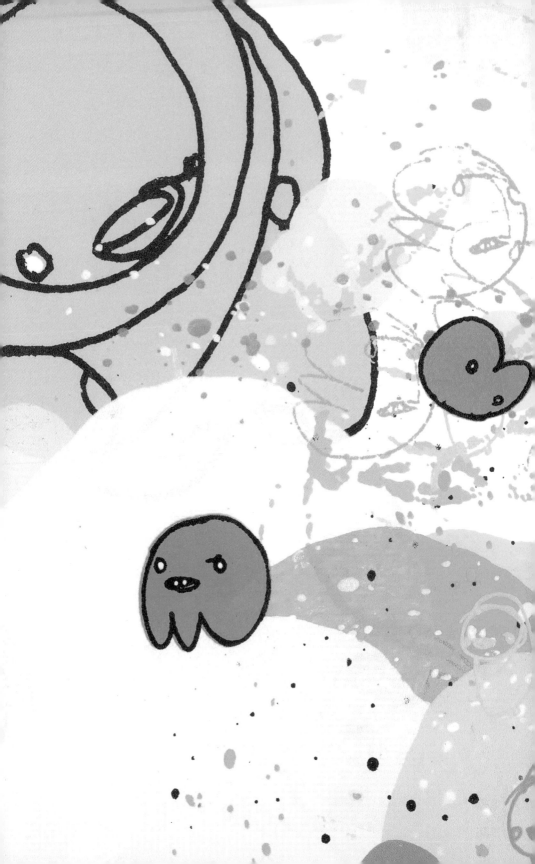

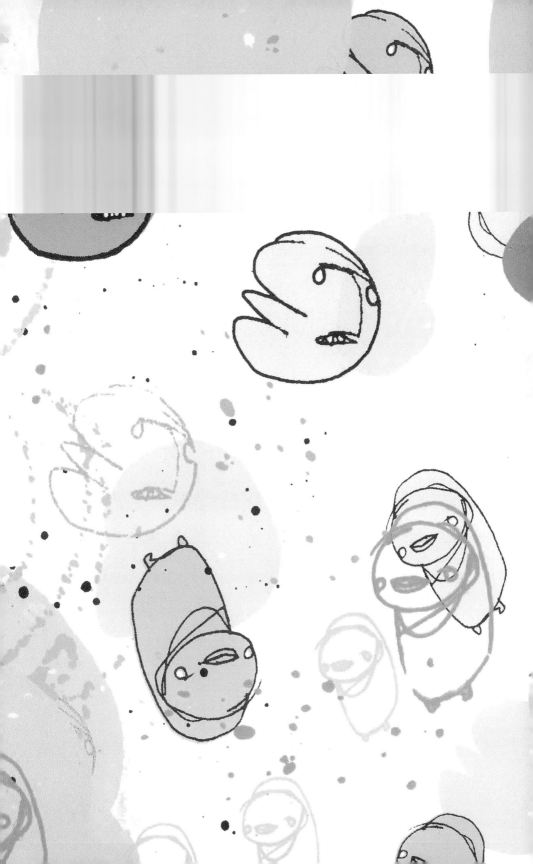

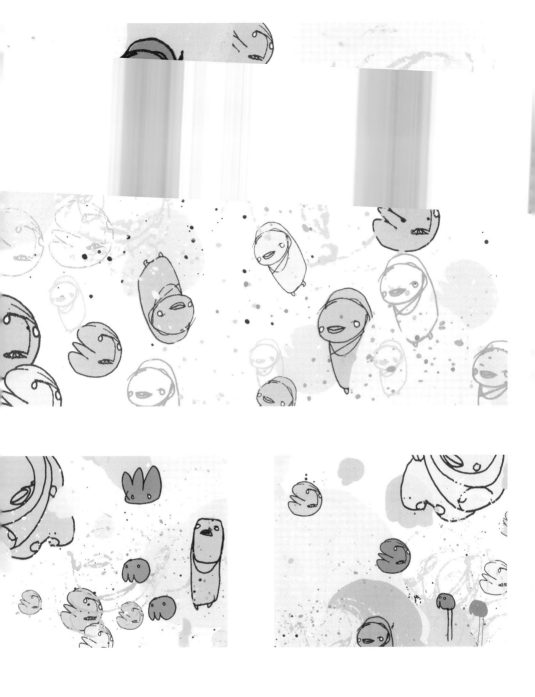

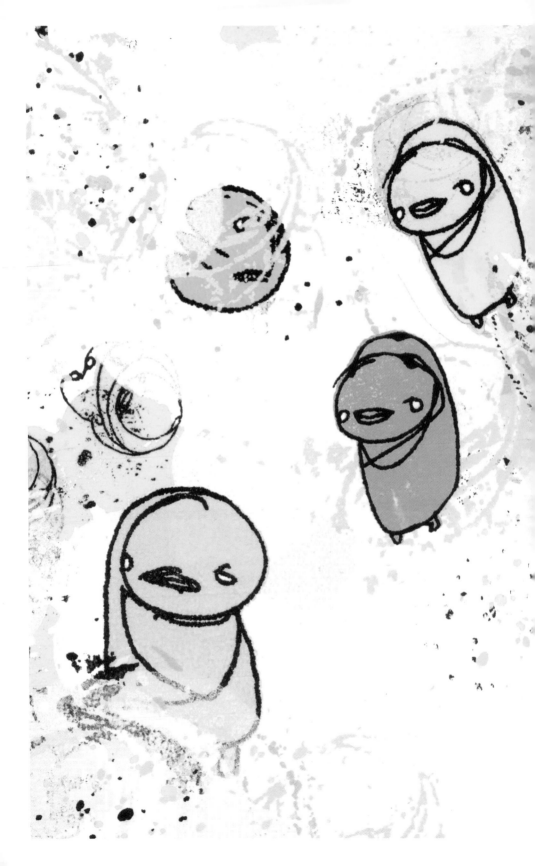

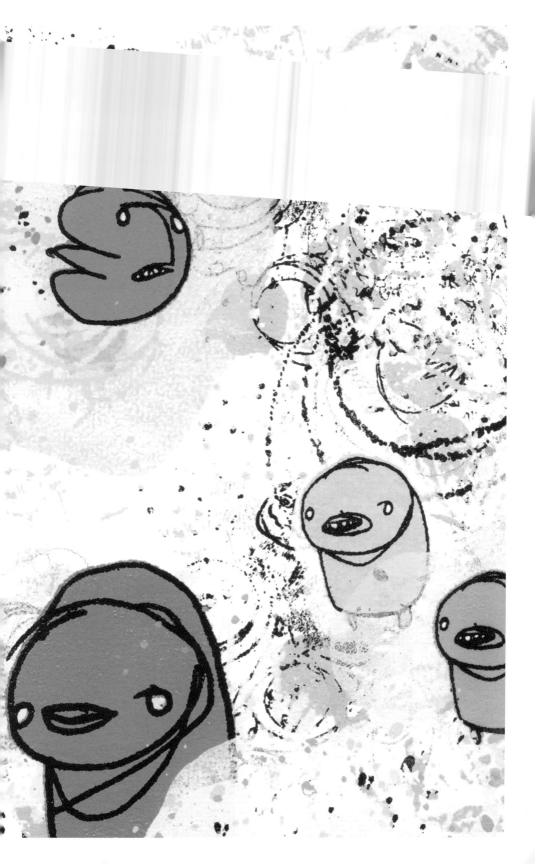

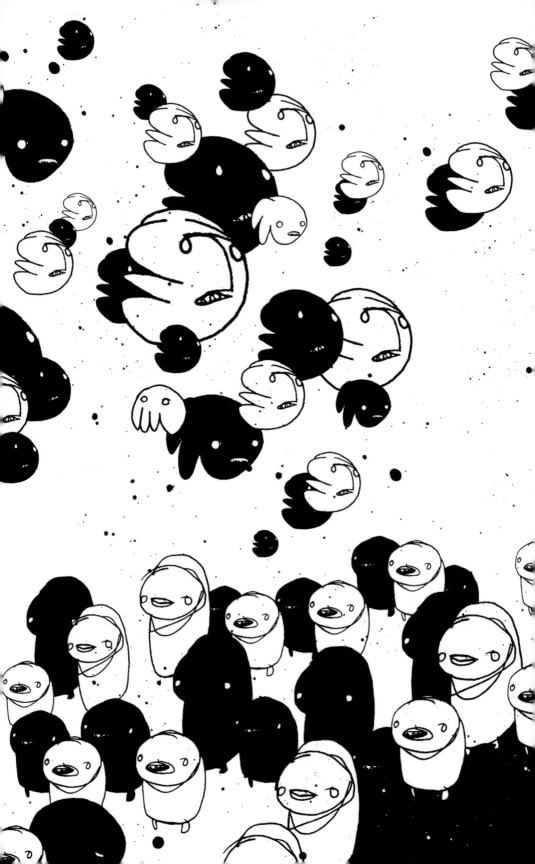

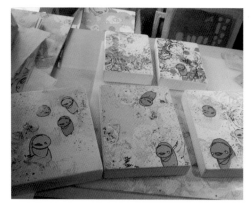

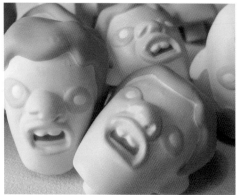

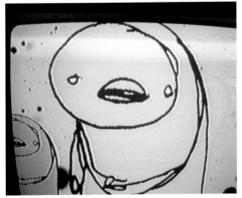

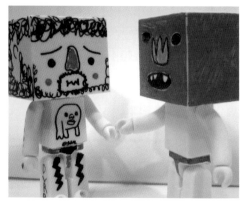

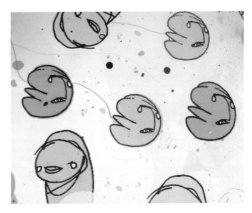

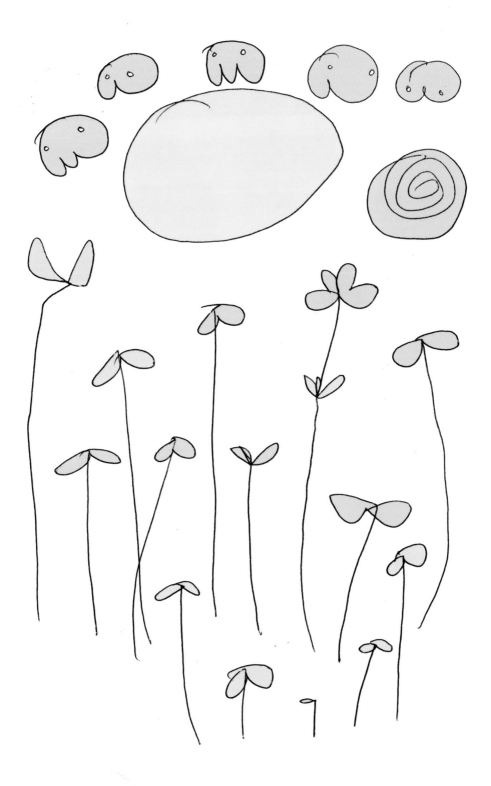

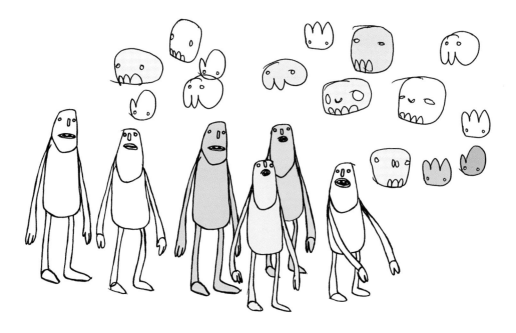

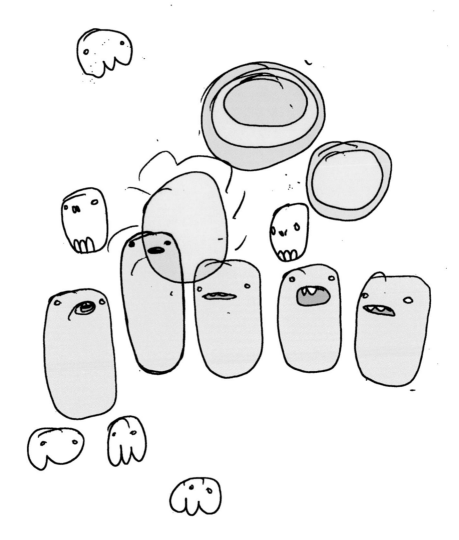

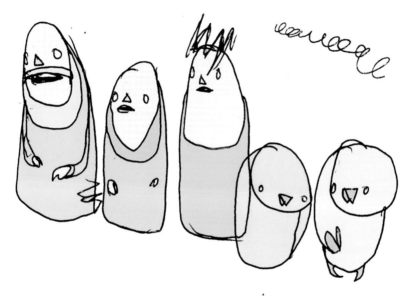

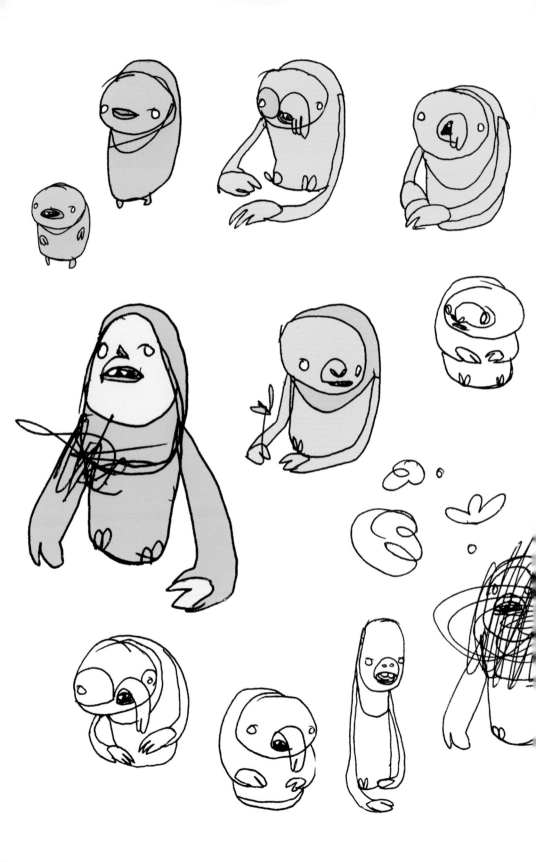

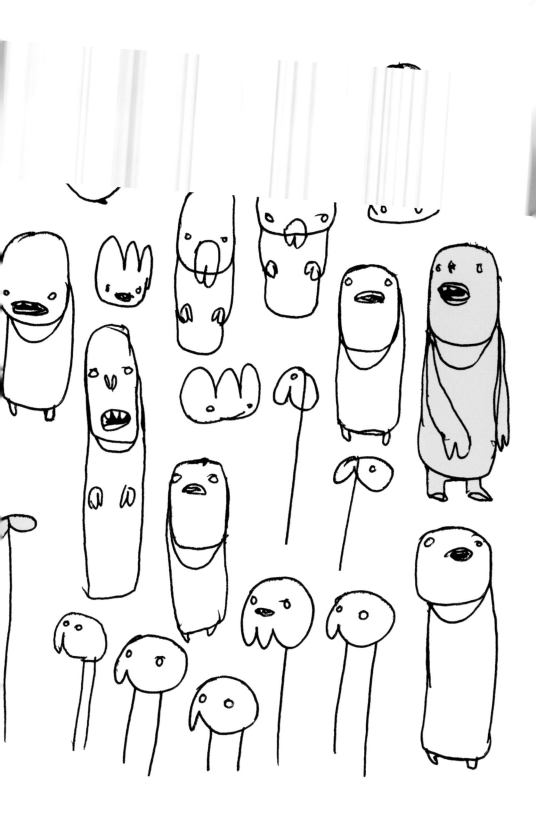

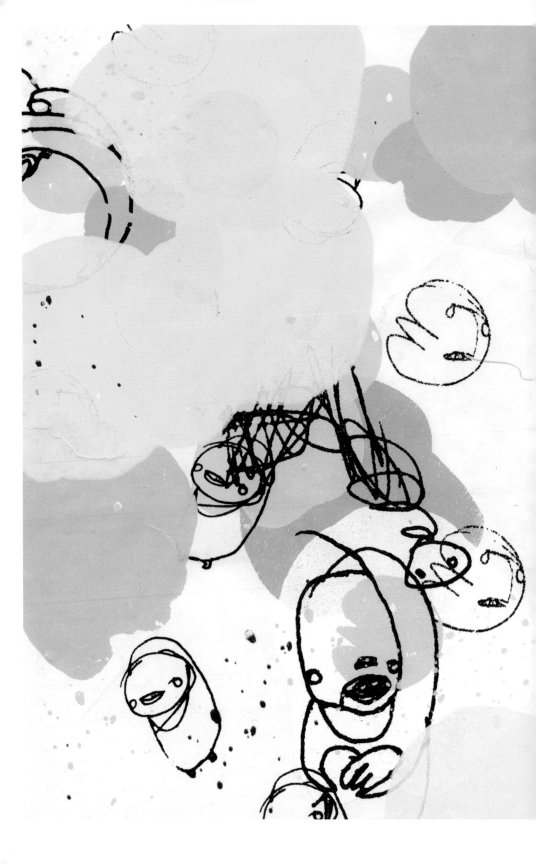

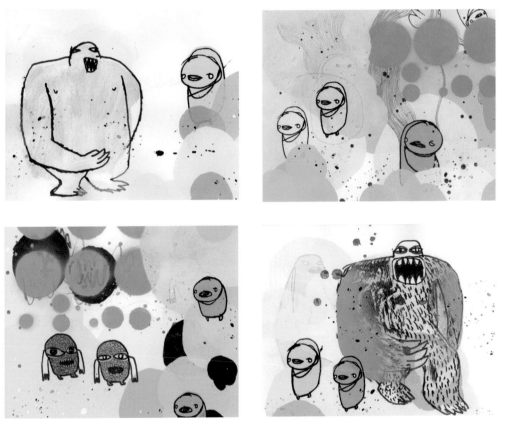

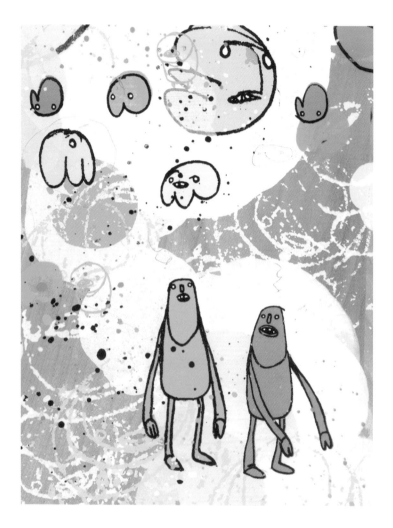

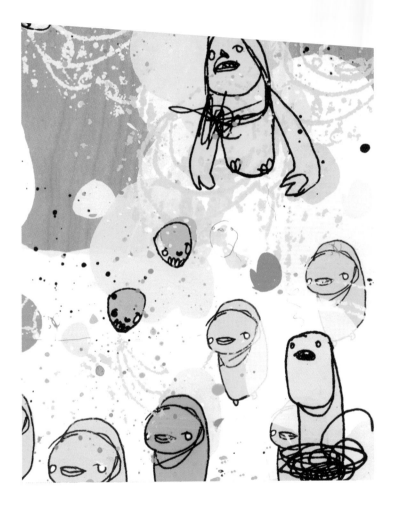

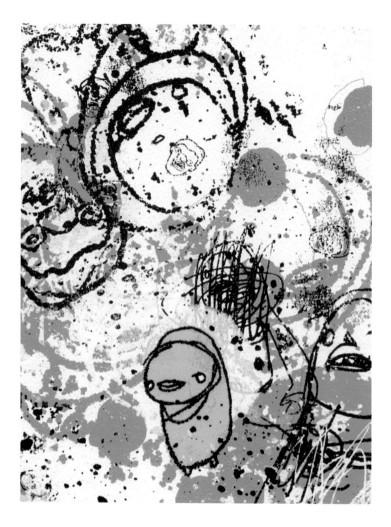

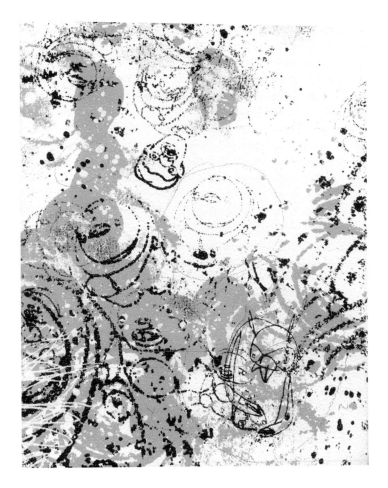

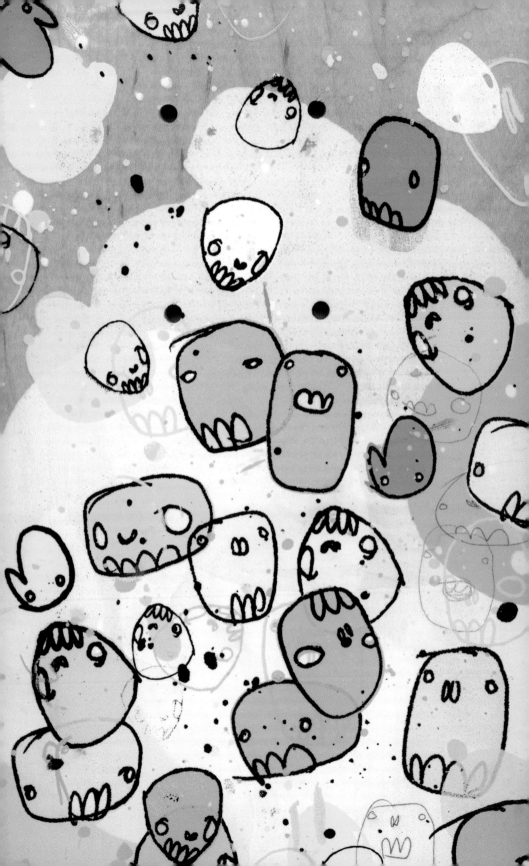

Character
Glossary

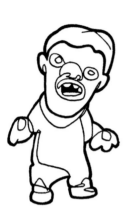

Jim Stickney

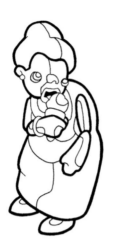

Granny

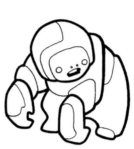

Space Ape

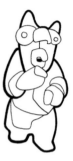

Mania Boy

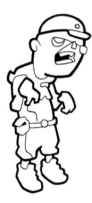

Zombie Scout

Zombie Scout

Mogo

Bluebee

Fly'n Jackass

Ditch Pig

Mogo

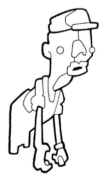

Zombie Farmer

Screech Pig Floater Mogo Floater Mogo Floater

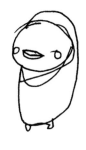

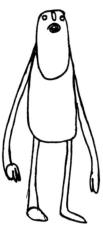

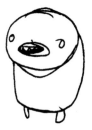

Land Slug Peeper Sprout Walker Jumper

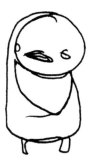

Grump Peep Bucky Peep Micro Peep Mega Peep

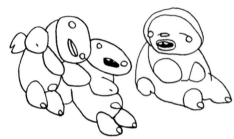

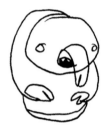

Popper

Bush Babies

Long Nosed Poker

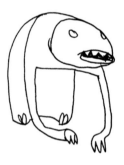

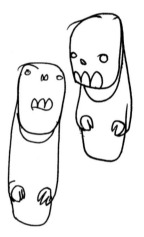

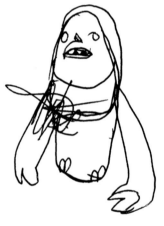

Howler

Skull Ghouls

Scritch Zombie

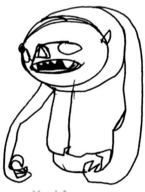

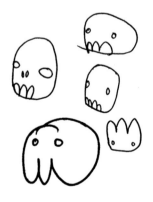

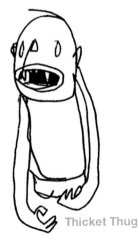

Yard Ape

Skull Spores

Thicket Thug

Clone Farmer

Clone Farmer

Mini Beefers

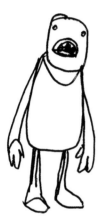

Thing Zombie

Chammy Ghoul

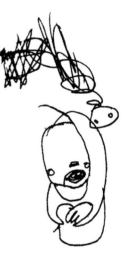

Touch Scritch

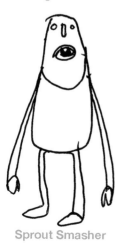

Sprout Smasher

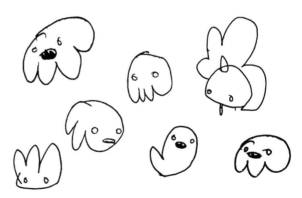

Sprout Spores

my mania is

numbugg'n
visual stewing
mogo love
ray'n out
same sames
the box life
assed out cobo wagons
the riparian zone
square bales, seven high
50 'o' fresh
the echo chamber
bush jump'n
space scrapie
getting wibbied
balls out, tits up
bagg'n root
chammied to the max
low down saggy tits
pig dirt

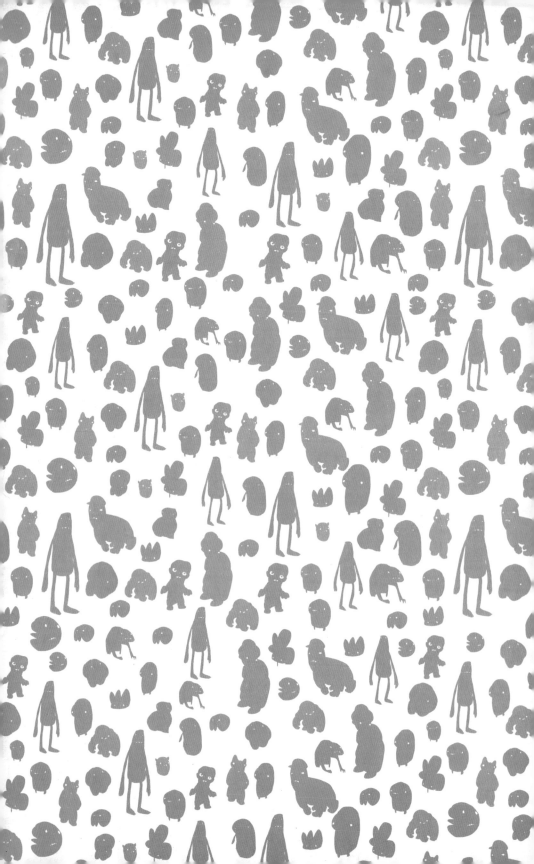